CECIL BEATON

Published by IWM, Lambeth Road, London SE1 6HZ
iwm.org.uk

ISBN 978-1-912423-41-5

A catalogue record for this book is available from the British Library.
Printed and bound by Gomer Press Limited
Colour reproduction by DL Imaging

Every effort has been made to contact all copyright holders.
The publishers will be glad to make good in future editions any
error or omissions brought to their attention.

Front cover: A sailor repairing a signal flag during HMS *Alcantara*'s
voyage to Sierra Leone, West Africa, 1942.

Back cover: A welder at the Walker Naval Yard on the River Tyne,
North East England, 1943.

CECIL BEATON

Geoffrey Spender

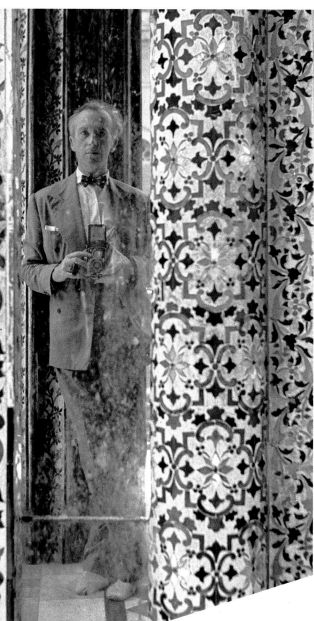

A self-portrait
of Beaton, taken
in a mirror at the
Parshwanath Jain
Temple in Calcutta,
1944.

Cecil Beaton (1904–1980) was a figure of wide-ranging talents. He was a photographer who worked in the fashion industry for *Vogue* and *Vanity Fair* in the United States. He took society portraits of the great and the good in London, where he was also a popular photographer of the Royal Family. He had a lifelong interest in theatre and over the years he developed a career in stage design and costume work. When war was declared against Germany in 1939, however, he had a problem. He desperately wanted to contribute to the war effort, but he knew he was no soldier. He volunteered for the Air Raid Precautions (ARP) service and spent his free time photographing London in the shadow of the Blitz. It was these photographs, and the influence of his well-connected acquaintances, that led to his most famous wartime occupation.

Queen Elizabeth, wife of King George VI and the future Queen Mother, while choosing one of Beaton's portraits of her for the 1939 official Christmas card, suggested that he might find a role as a propaganda photographer. He could turn his eye to photographs that would bolster morale among the military and civilian population, and that might garner the sympathy of neutral nations. His Blitz photography had made waves in the USA prior to that nation's entry into the war. The Ministry of Information (MoI), it turned out, was looking for skilled photographers who would be willing to produce propaganda material showcasing the strength and resourcefulness of Britain, its allies and its imperial subjects. His well-established reputation as a portrait photographer led to him being commissioned by the British government for a series of portraits of ministers, which resulted in further MoI assignments. Ultimately, though, it was Randolph Churchill, son of the prime minister, who requested the minister of information send Beaton to North Africa to document

the campaign there. And so, in early 1942, he travelled on behalf of the MoI to Cairo – a hub of the British presence in the region.

Cairo became his base of operations, but he also spent time in other parts of the Middle East, including Egypt's Western Desert, photographing Royal Air Force (RAF) men at their remote encampment. He even travelled into Tobruk in Libya, which had been taken from the Italians the previous year and would fall to the German army only a few months later. The desert may have been his first experience of a rugged wilderness lifestyle, but despite his refined manners and the open secret of his bisexuality he apparently became a well-liked figure among the airmen and ground crews. Beaton's willingness to get involved socially and to share stories of other places he'd been and people he'd met proved to be an icebreaker on all of his travels.

After his trip to the desert Beaton returned to Cairo. However, the situation in North Africa grew more uncertain in the face of the German push under Field Marshal Erwin Rommel, so Beaton returned home via Nigeria and Portugal in July of 1942.

After spending part of 1943 producing a series of portraits of shipyard workers in the UK, Cecil Beaton's next major overseas assignment came in December of that year. He was dispatched to India where British Empire forces were battling against the Japanese on the Burmese border. As in Egypt, Beaton found enclaves of British high society in Calcutta and Delhi – moving in social circles not unlike those he knew back in London and New York. However, he was again sent to the front lines – this time to the Arakan region where fighting was fierce. Beaton came much closer to the front lines here than he had in the Western Desert and saw fresh casualties returning from battle. Here he met not only British soldiers but also Indian, Nepalese and African troops. During his time in India, Beaton also visited Bombay, Hyderabad

and Jaipur and took a memorable trip to the North-West Frontier near Peshawar, where the Khyber Pass connected India (now Pakistan) with Afghanistan.

In April 1944 Beaton made a visit to Chongqing and Chengdu in China to observe and photograph Chinese efforts against the Japanese and to see how ordinary life was continuing in the region. While he found China very beautiful from a photographer's perspective, he suffered from poor weather and a lack of home comforts, so his time there was short and unhappy. He also survived a plane crash and bouts of illness during this period, worsening an already stressful assignment. He returned to India in June 1944 and then travelled homeward.

This book contains just a sampling of Cecil Beaton's war photography, of which IWM holds around 7,000 examples. Some of these images are world-renowned, while others have rarely appeared in print before. We have focused in particular on his two tours abroad for the MoI, which offered him a great variety of artistic subjects. While Beaton took many slice-of-life photographs and portraits of society figures in distant parts of the Empire, the focus in this publication is on scenes and people directly connected with or affected by the war. Beaton's mission was to portray a British Empire that remained united and resolute in the face of its enemies, an unapologetic propaganda effort. His work may sometimes be considered lacking to modern eyes for the way it ignores the fault lines and injustices of empire, but the humanity of those he was photographing, whether British or colonial subjects, shines through in his work. In these photographs we see Beaton's constant fascination with people: the way they look, the way they live and the way they bear the burdens of war.

One of Beaton's portraits of
Winston Churchill, taken in 1940.
Beaton was permitted five minutes
of the prime minister's schedule
to take photographs and found
him a grumpy but obliging sitter.

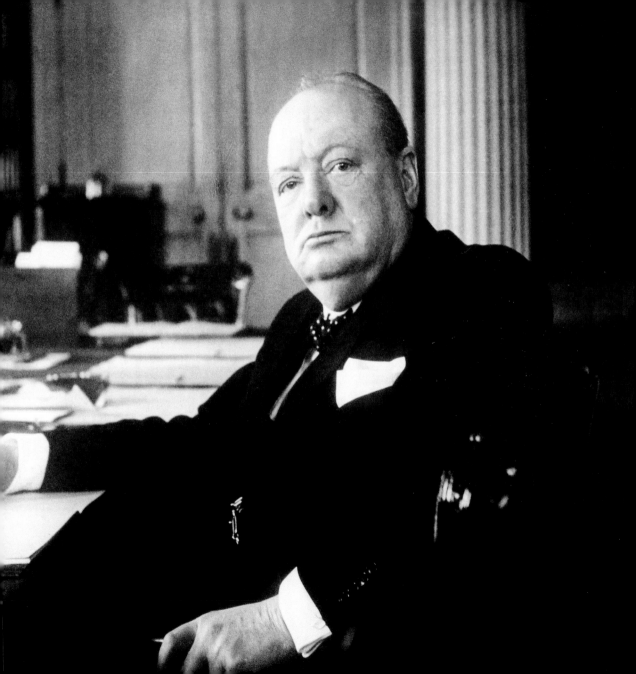

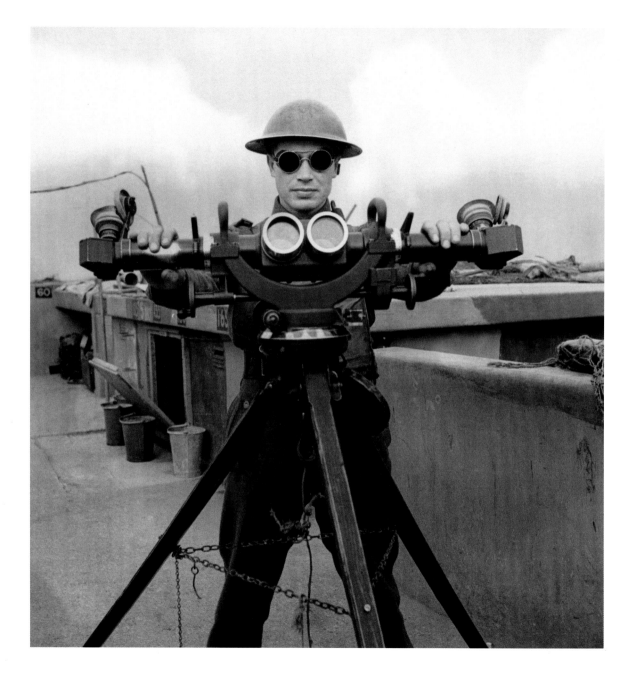

Before his overseas work began, Beaton took photographs of scenes and people on the home front. This soldier of the Royal Artillery is using a rangefinder at Dover, Kent, 1941. The composition of the image reflects the square photo prints that Beaton typically produced.

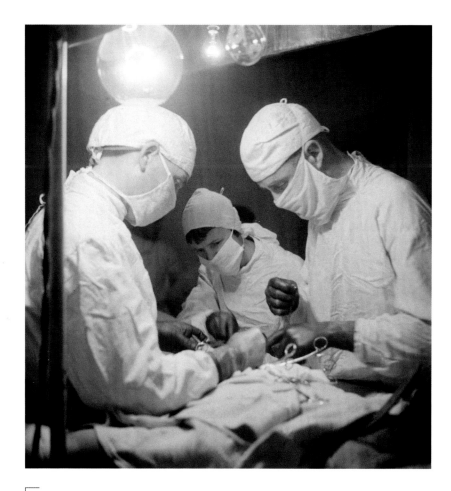

Colonel Philip Astley, Assistant Director of Public Relations, at General Headquarters in Cairo, Egypt, 1942. Note the messy state of his desk.

A dramatically lit surgery being carried out at Tobruk, Libya, 1942. The patient is a young South African soldier injured by a mine.

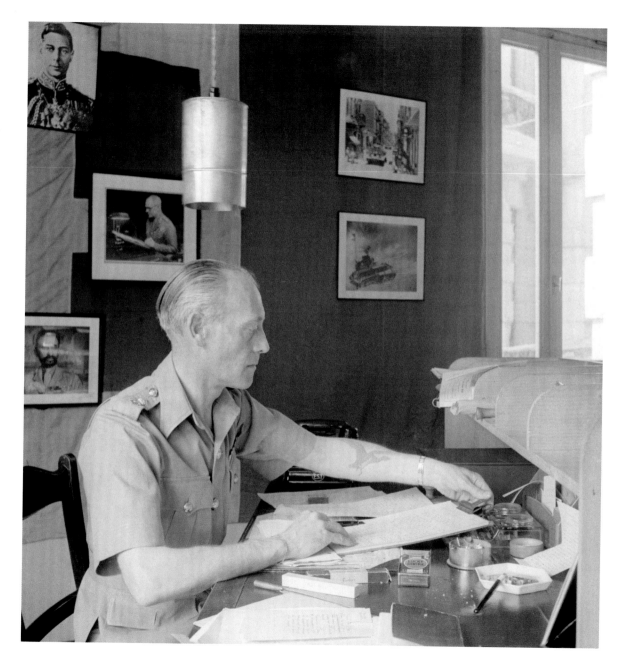

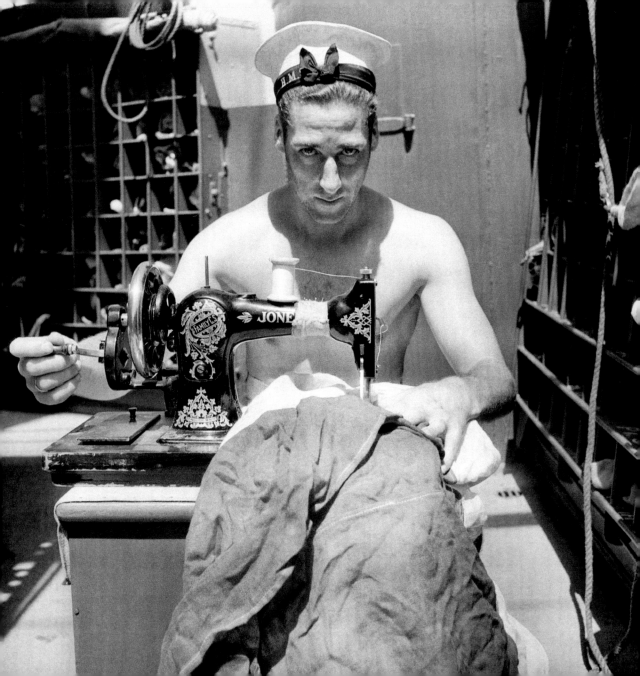

A sailor repairing a signal flag during HMS *Alcantara*'s voyage to Sierra Leone, West Africa, 1942. This has since become one of Beaton's most well-known wartime images following its use in an IWM exhibition during the 1980s.

Young sailors relaxing
on the roof of the Under
Twenty Club, Alexandria,
Egypt, 1942.

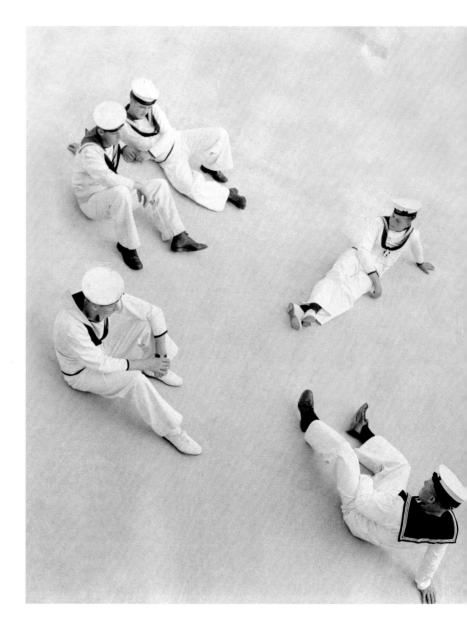

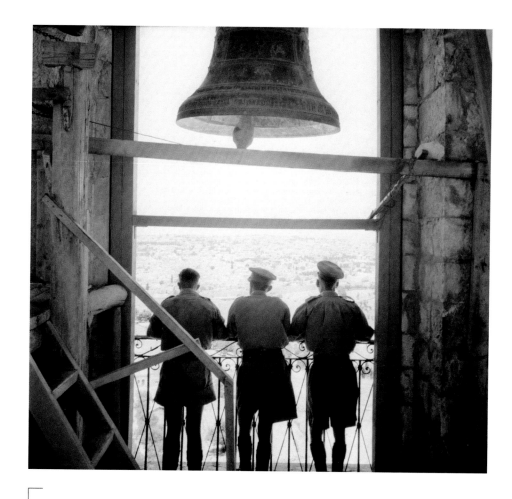

Soldiers silhouetted as they look
down on the Mount of Olives from
the tower of the Russian Church in
Jerusalem, Palestine, 1942.

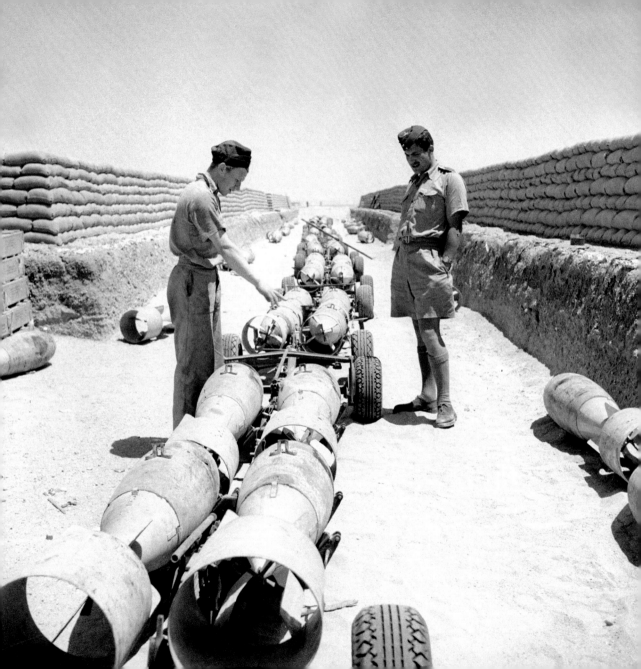

A long train of bombs is laid out for inspection before loading on to planes. RAF Shallufa, Egypt, 1942.

An RAF engineer walks along
the wing of a Vickers Wellington
aeroplane to check it is ready for
operation, RAF Shallufa, Egypt,
1942. Beaton took most of his
desert photographs close to
dawn or dusk, when the light
was most suitable.

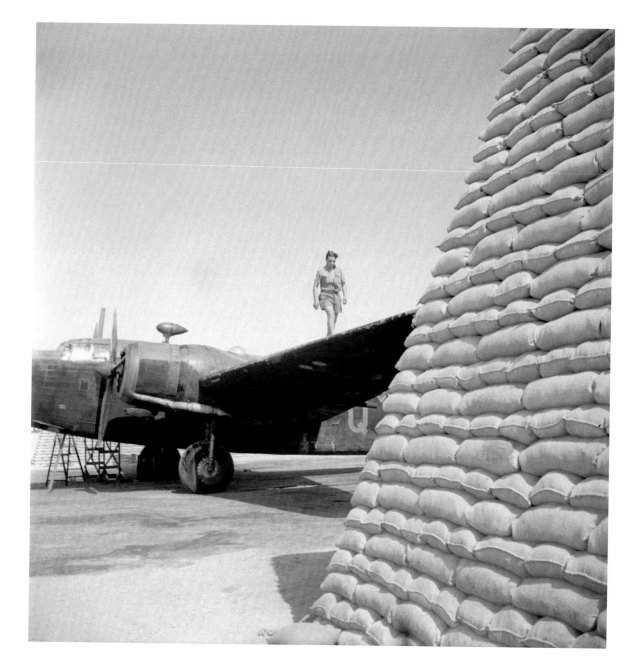

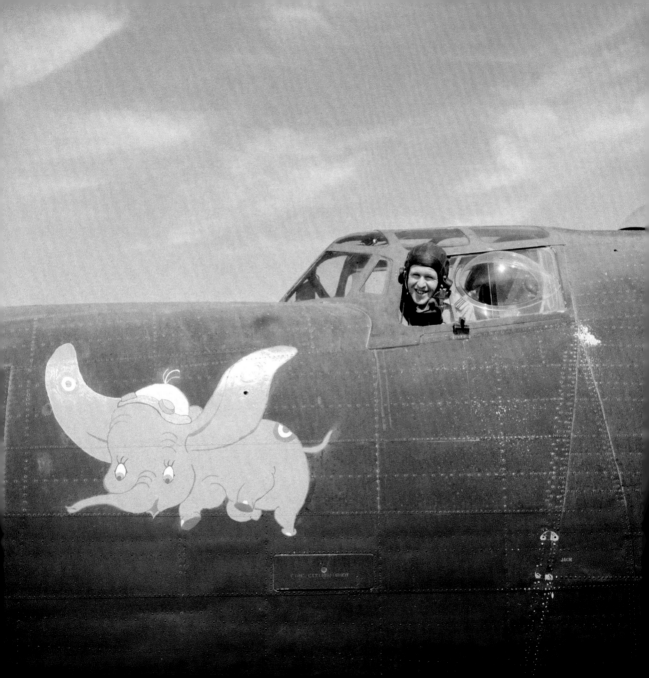

A smiling pilot sits in the cockpit of his aircraft, which has the Disney character Dumbo painted on its fuselage, location unknown, 1942.

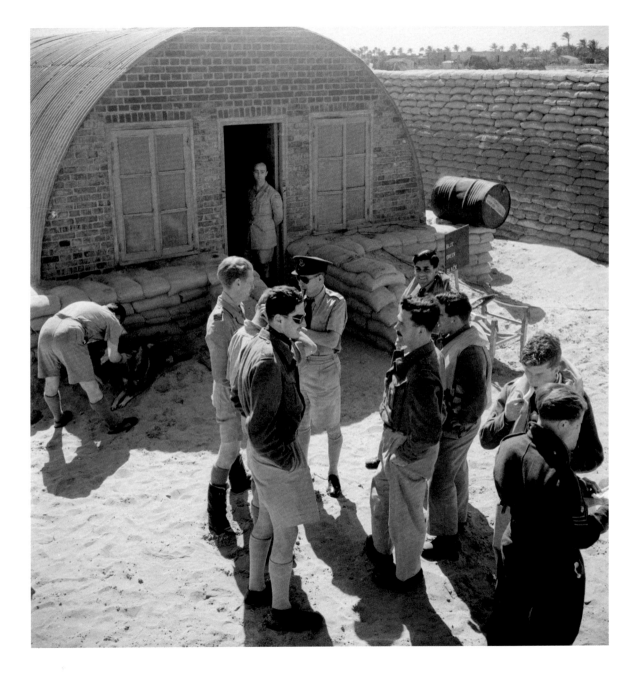

Greek airmen of No. 335
Squadron at El Daba air base
near Mersa Matruh in Egypt,
1942. Beaton often tried to
capture the social interactions
of men in a naturalistic way,
alongside his more carefully
arranged portrait photography.

A Fleet Air Arm (FAA) plotting
room somewhere in the
Western Desert, 1942. The
poster is a guide to identifying
enemy aircraft from the ground.

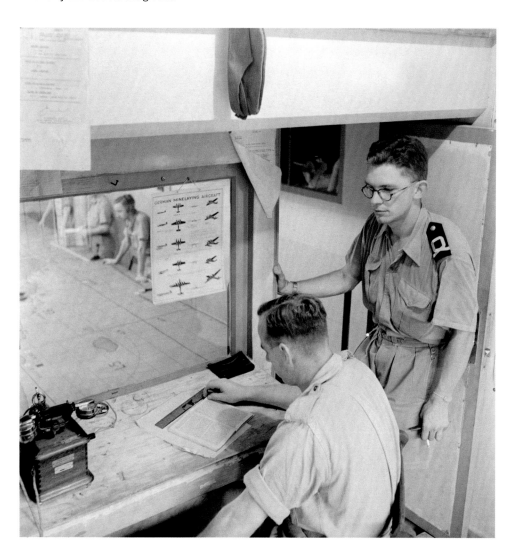

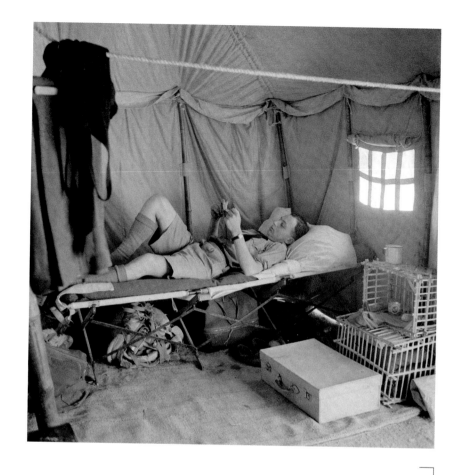

An RAF officer resting in his tent, which is full of furniture improvised from bomb boxes and tangerine baskets, 1942.

An airman smoking at sunset, 1942. Beaton said of the desert, 'At the moments before dark the whole landscape becomes magic... turning the sand to powder and the sky to opal.'

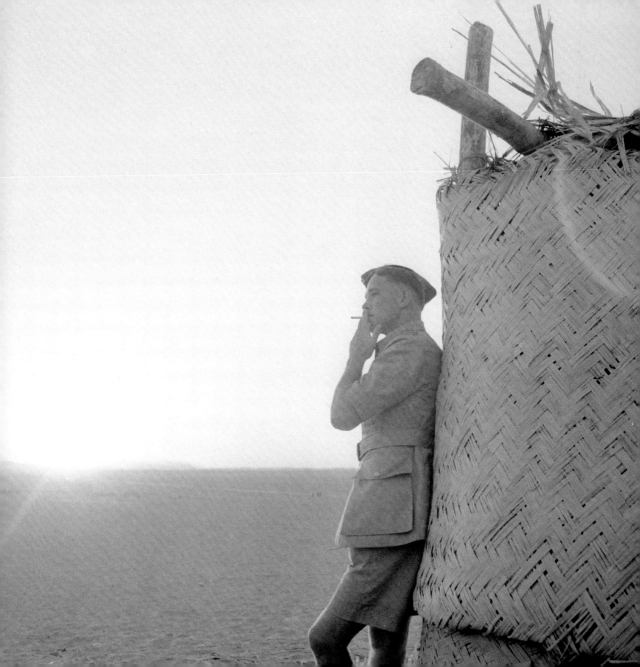

Alice Delysia (1889–1979) was a French singer and actress who was well known in London's West End. During the war she entertained troops in the Middle East, which is where Beaton photographed her. The two both left their comfortable lifestyles as London celebrities to aid the war effort in their own way. This photo was taken in 1942.

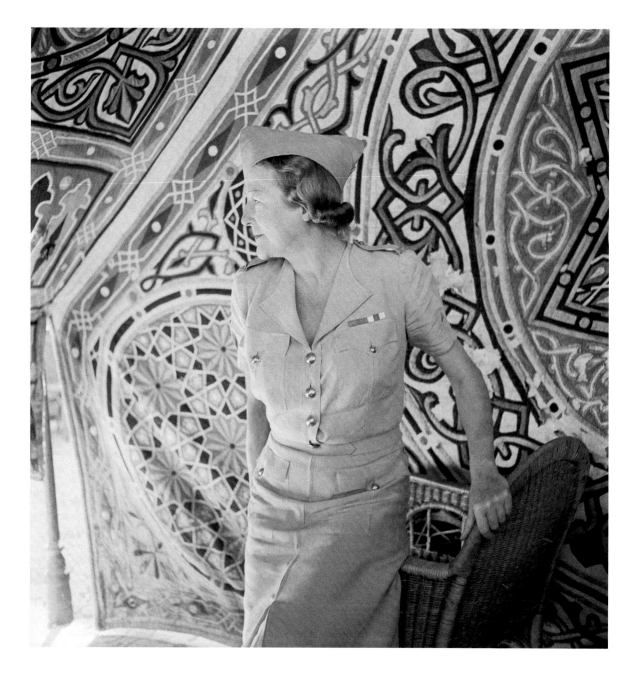

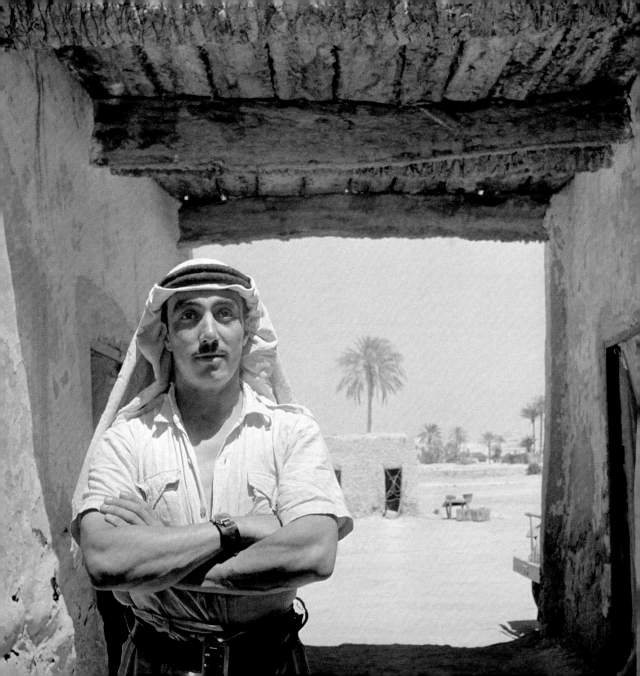

A soldier of the Long Range Desert Group (LRDG) at Siwa Oasis, Egypt, 1942, wearing an Arab-style headdress. Beaton was fascinated by these men, whose rough and dangerous lifestyles were so different to his own.

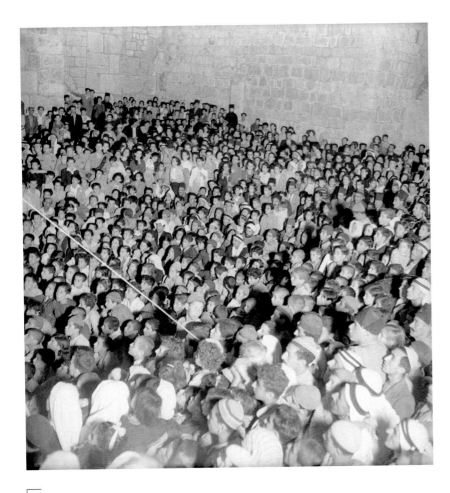

Captain Burger, from Johannesburg, South Africa, performed as many as 18 dental fillings a day in his desert trailer surgery. In March 1942 he undertook 422 cases, including 150 dentures and 128 repairs.

A great crowd of civilians gather outside the Church of the Nativity in Jerusalem, Palestine, for the open-air screening of a propaganda film, 1942.

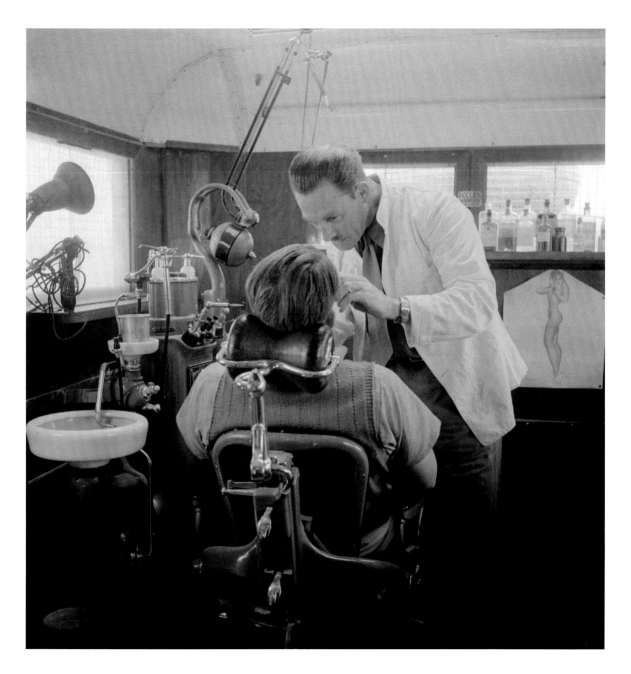

A navy man getting his head
shaved in Tobruk, Libya, 1942.
Beaton captures a typical slice
of life in this photograph.

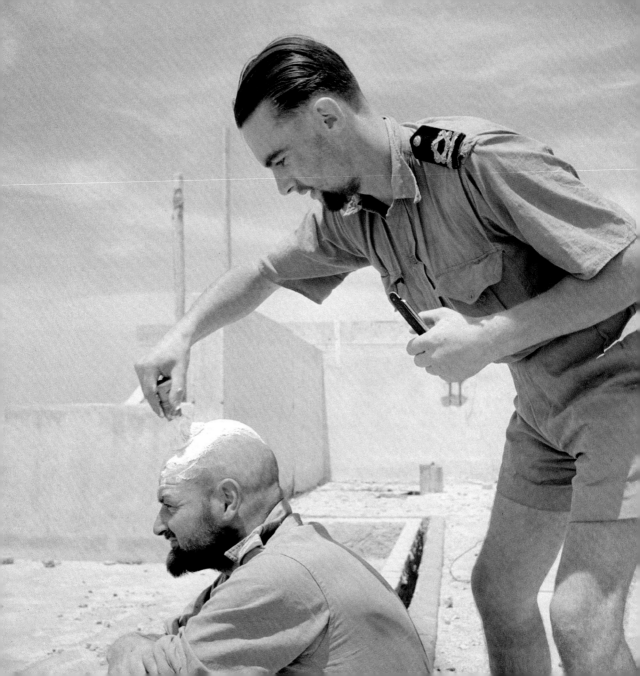

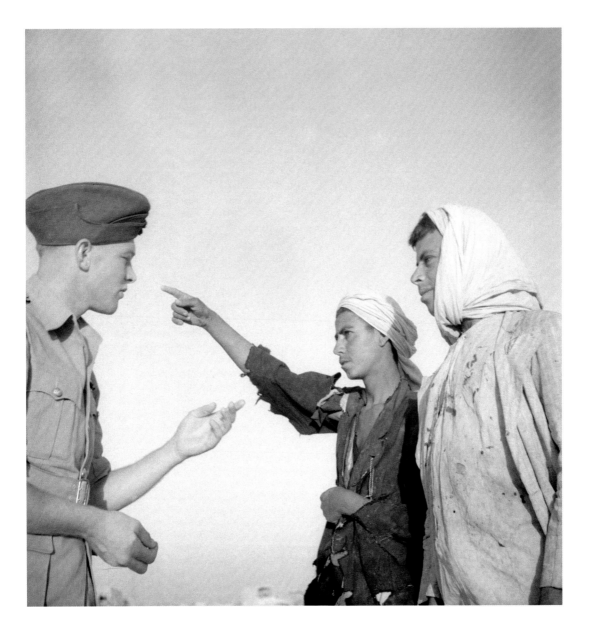

An airman speaking with locals at an unknown location in North Africa, 1942. There are relatively few photographs of civilians from Beaton's visit to this region, but these men seem willing to pose for the camera.

Randolph Churchill, son of the
prime minister, 1942. He was
a key figure in recommending
Beaton for posting to North Africa,
where he was also stationed.
This photo contains crop marks,
placed by Beaton himself, to
indicate how the photograph
was to be printed.

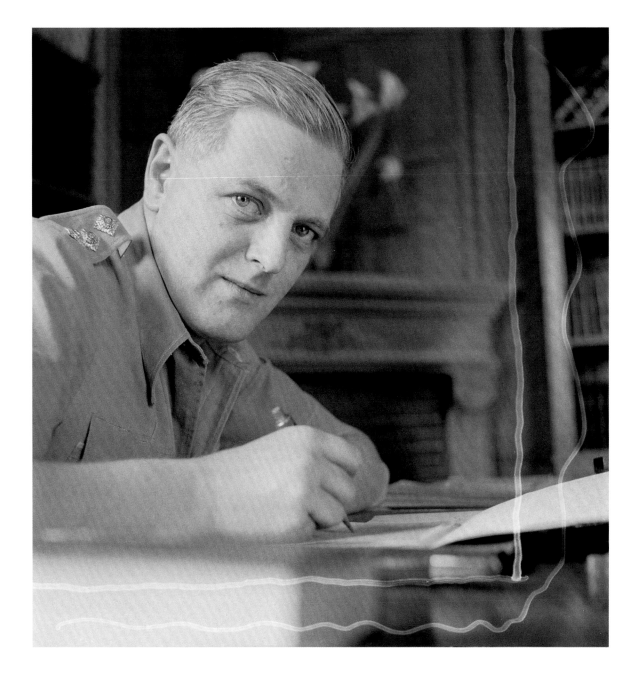

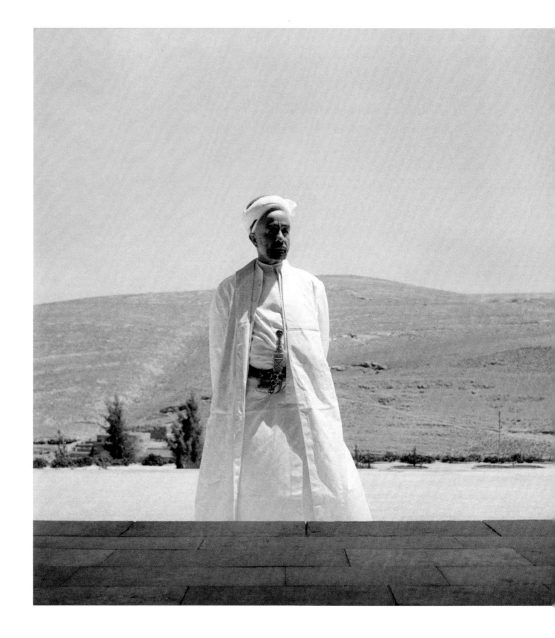

Emir Abdullah of Transjordan at his palace in Amman, June 1942. Beaton was at home photographing society figures and royalty and continued the practice in his overseas war work. The Emir was an ally of the British war effort and was rewarded with independence for his kingdom in 1946.

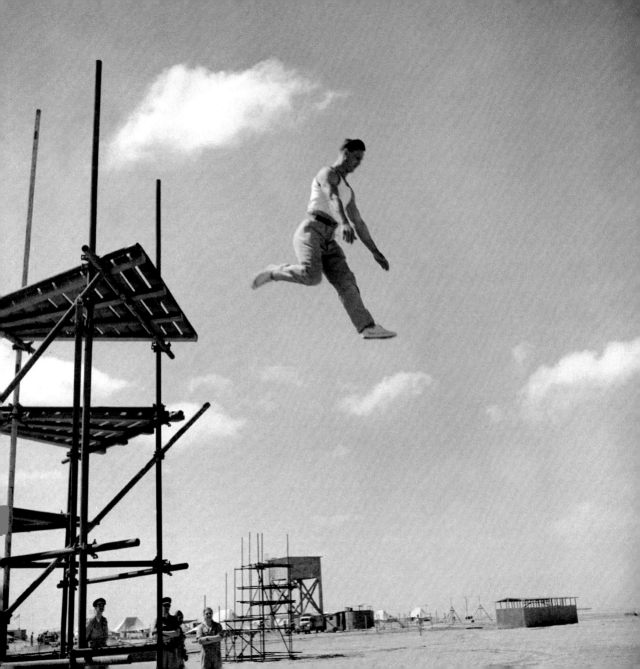

A paratrooper jumping from a scaffold tower during training in 1942. The Second World War was the first war to use paratroopers, and it would have been a striking and startling new feature of conflict.

Polish refugee children in the Middle East. Many civilians in Soviet-occupied Poland fled south to Iran, Palestine and other places. Beaton photographed some of these children at a refugee camp in 1942.

A mechanic of No. 230 Squadron, Royal Air Force, repairing a piece of equipment in Alexandria, Egypt, 1942.

A British dispatch
rider in his motorcycle
helmet, somewhere
in Syria, 1942.

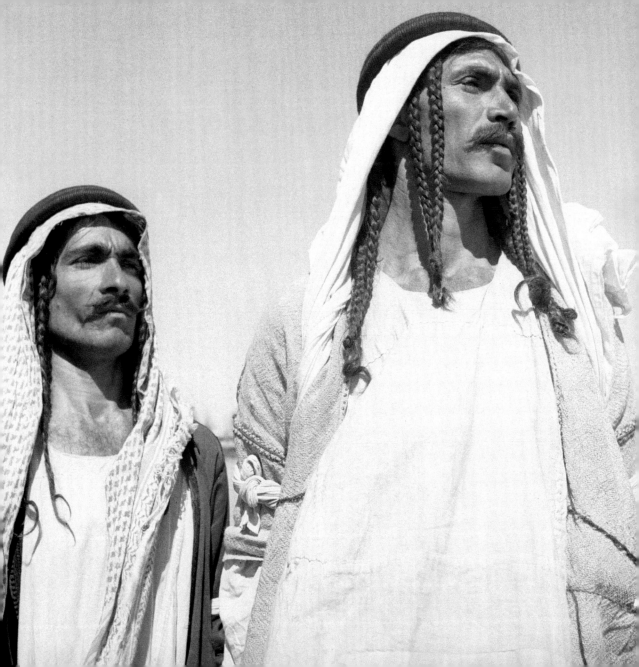

Two Yazidi men with traditionally styled plaited hair at their recruitment into the Iraqi Levies, 1942. Yazidis, Kurds and Assyrians were all recruited alongside Iraqi Arabs.

Iranian men at work in an
aircraft factory, 1942. The
British and Soviets invaded
neutral Iran in 1941 and forced
a change of government in the
country to one more willing to
help the Allied war effort.

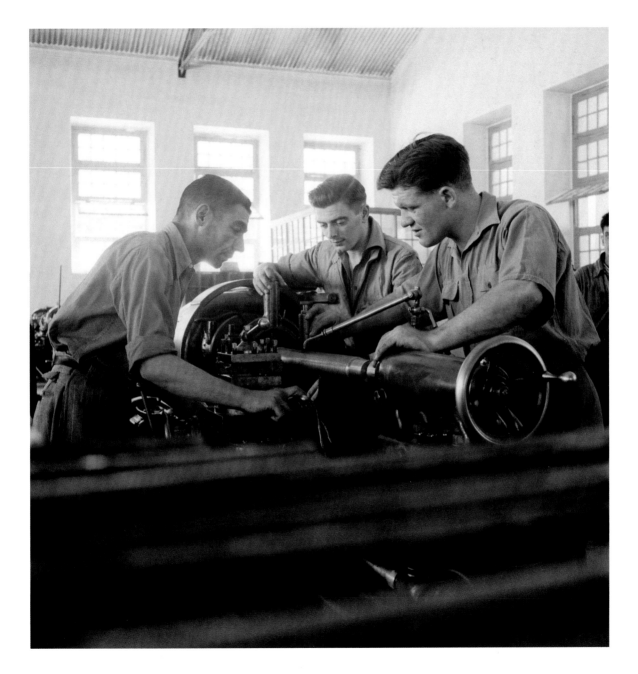

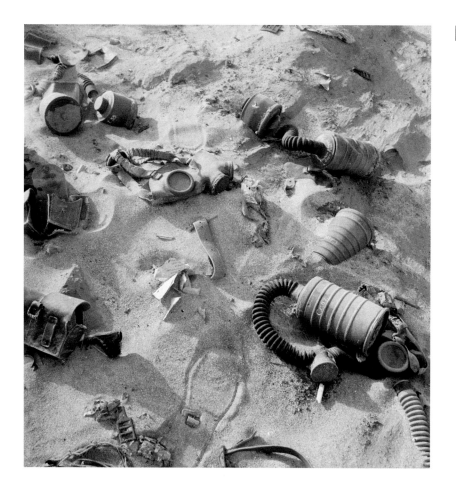

Abandoned equipment, including Italian gas masks, being reclaimed by the desert at the Halfaya Pass, Libya, 1942. Beaton did not visit the front line during the Western Desert campaign, but he had opportunities to photograph the aftermath of the Italian withdrawal.

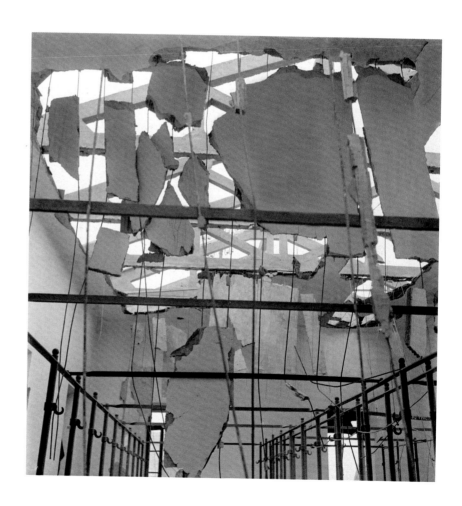

The remains of a fire station in Tobruk, Libya, 1942. The city was recaptured by the Germans and Italians shortly after Beaton's visit.

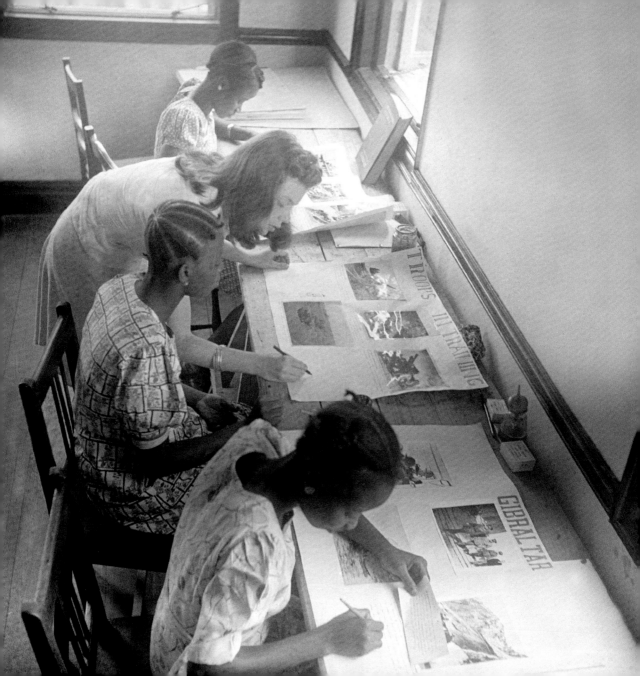

Beaton returned from the Middle
East via Nigeria. He visited this girls'
school in Lagos and photographed
children learning about the British
Empire and the war effort in 1942.

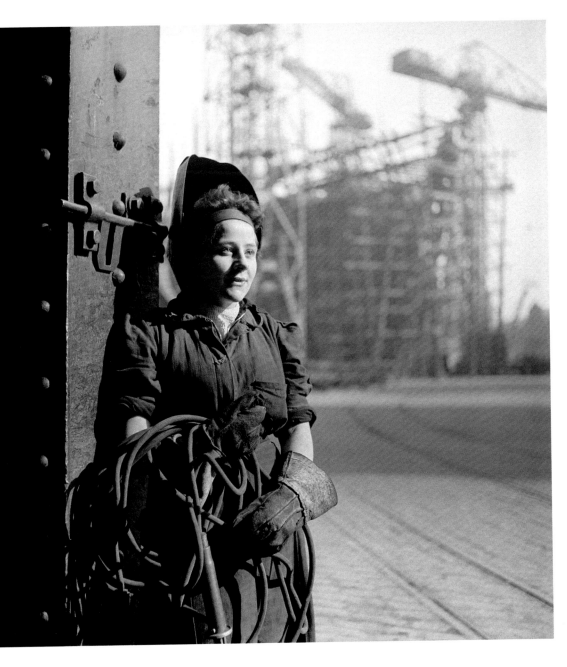

A welder at the Walker Naval Yard on the River Tyne. Beaton visited the North East of England in 1943 and photographed shipbuilders, including some of the many women who were recruited to fill the gaps left by male workers sent to fight.

An RAF pilot sleeping
between operations,
RAF Midenhall, c.1941.

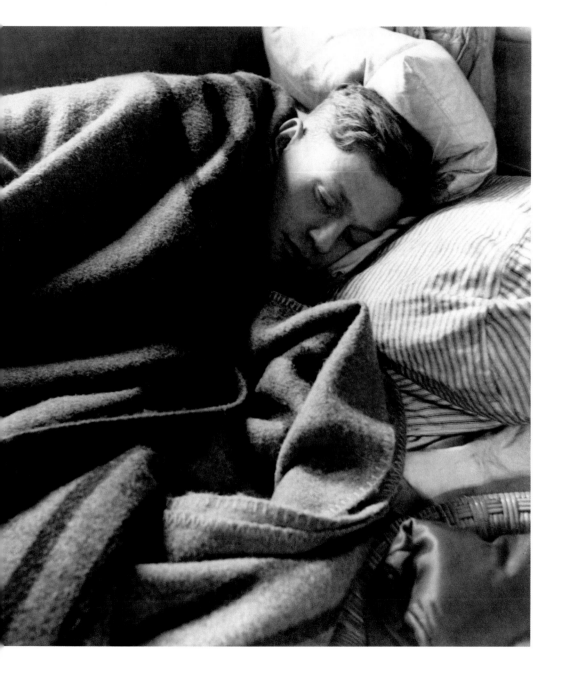

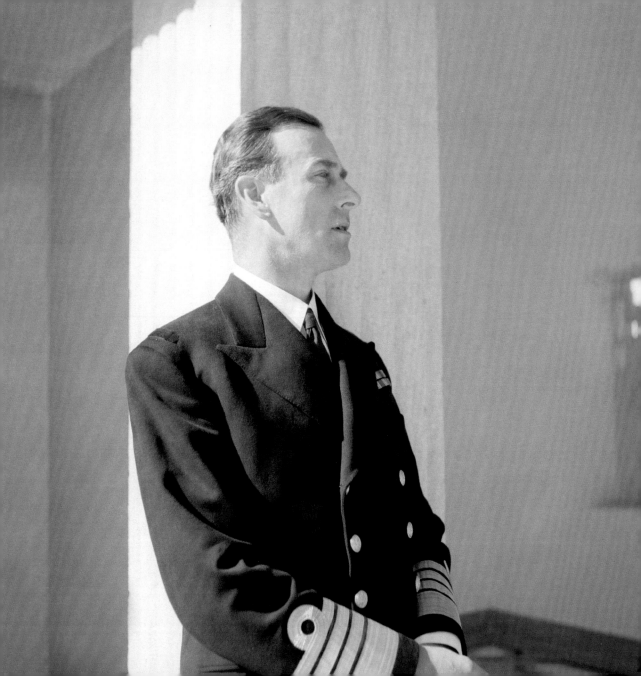

Admiral Lord Louis Mountbatten, Supreme Allied Commander, South East Asia, at his headquarters in Delhi, India, around December 1943.

14th Army unit on the Arakan
Front, Burma, 1944. The soldiers
rest amidst their supplies.
This was probably as close to
the front lines as Beaton came
during his time in Asia.

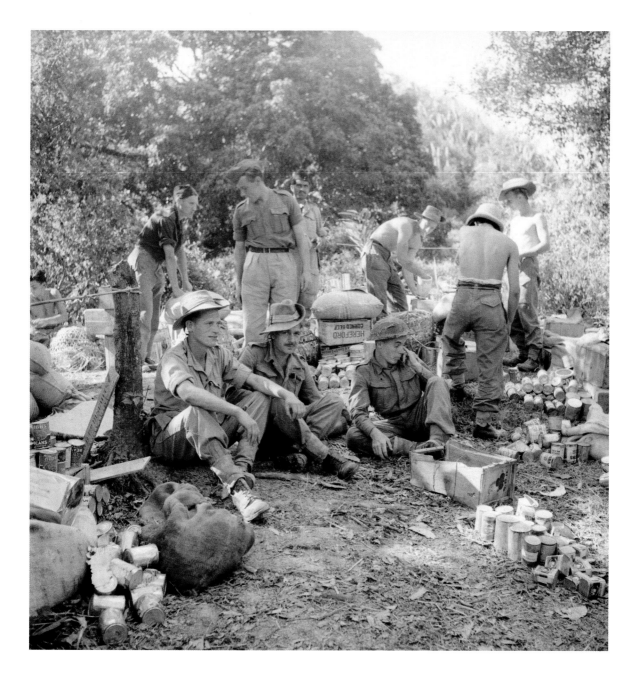

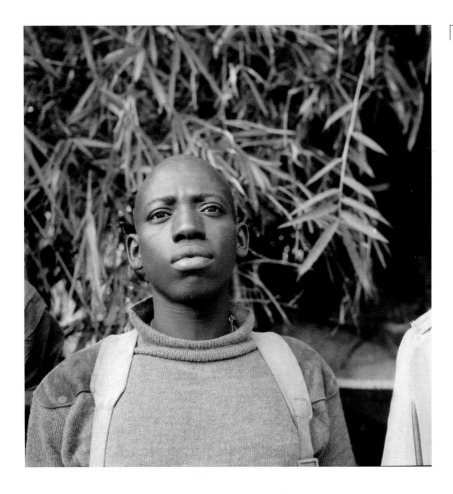

A soldier of one of the West African divisions on Burma's Arakan Front, 1944. Approximately 100,000 African soldiers were deployed against the Japanese in Asia, but their service was not rewarded as they might have hoped, in terms of pay or increased political rights at home.

An injured soldier in a hospital near the Arakan Front, Burma, 1944. Beaton seems to have chosen this man as a subject due to his many tattoos.

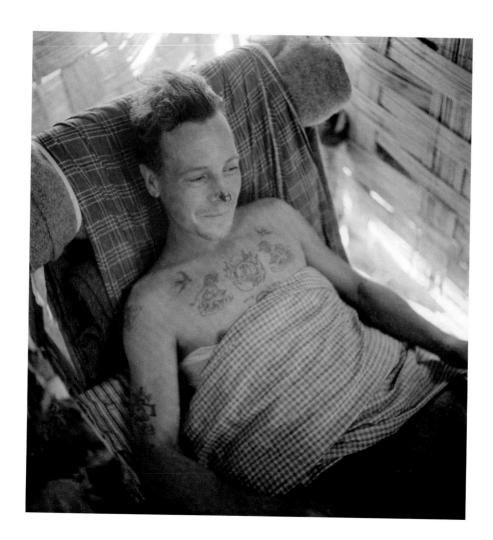

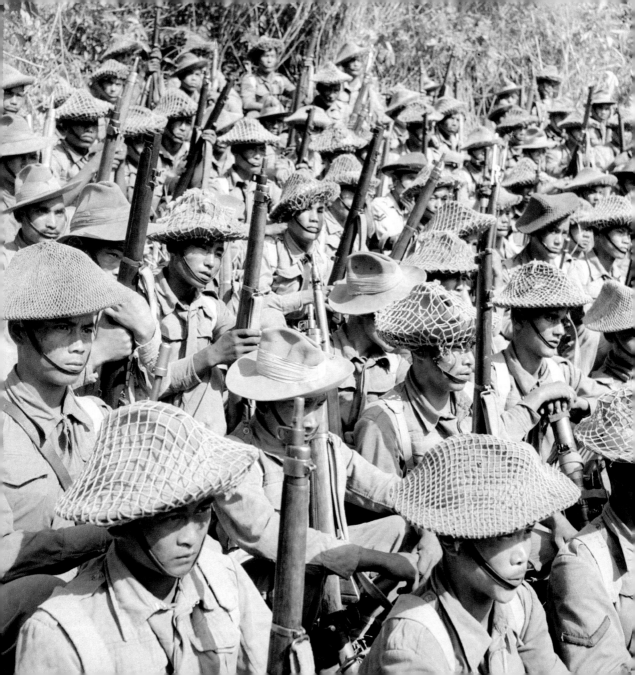

A large gathering of Gurkha
soldiers being briefed in the
jungles of Burma, 1944.

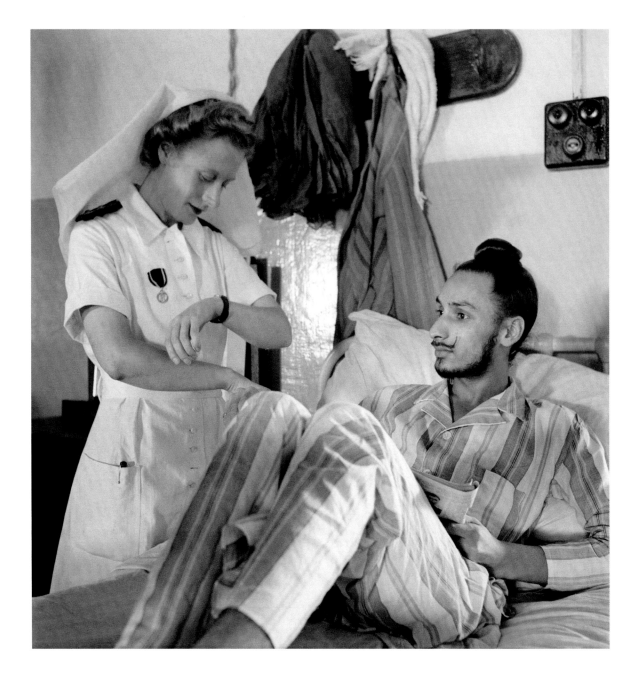

A Sikh officer being examined
by a nurse at the military
hospital in Colaba, India, 1944.
Beaton returned again and
again to hospitals and operating
theatres for his photography.

Some of the pilots training for the Indian Air Force (IAF) in 1944. The IAF was established in 1932 but the Burma campaign was its first true test.

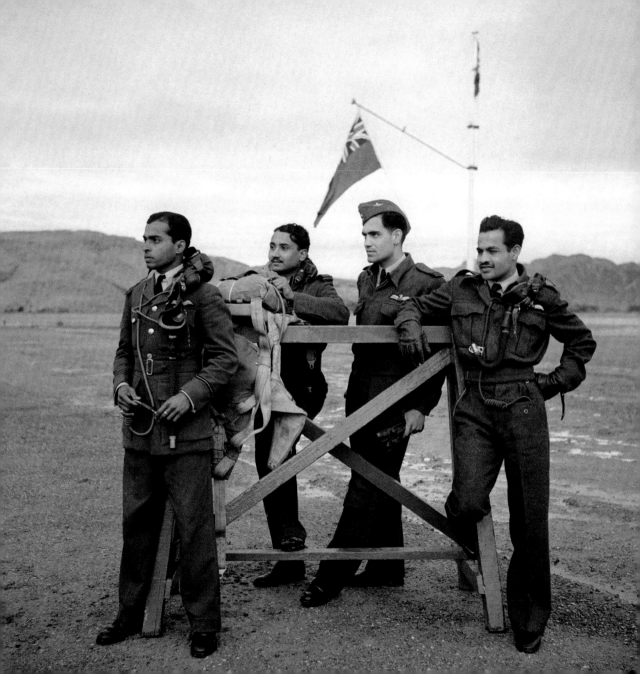

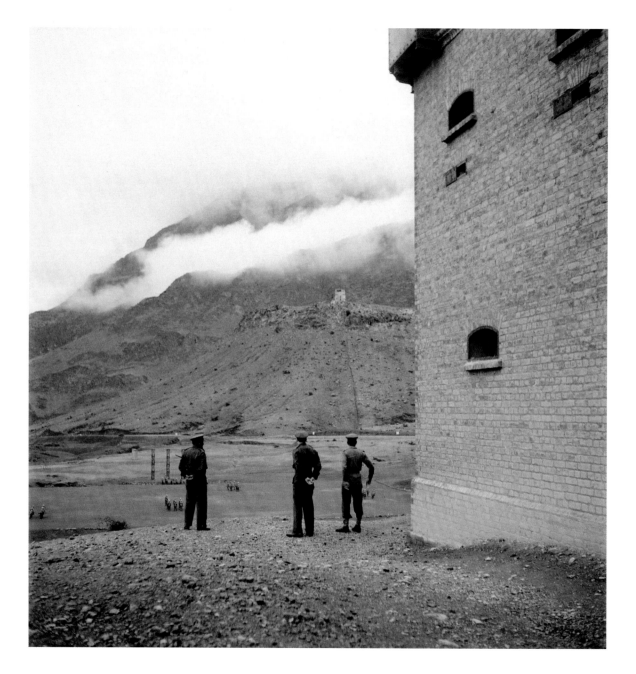

A view of the Ali Marajid fort at Shagai, 1944. Spectacular views of the Khyber Pass, which connected colonial India (now Pakistan) with Afghanistan.

The Forward Mess Deck of a
Royal Indian Navy ship in 1944.
The men are making chapatis
and pose for Beaton's camera.

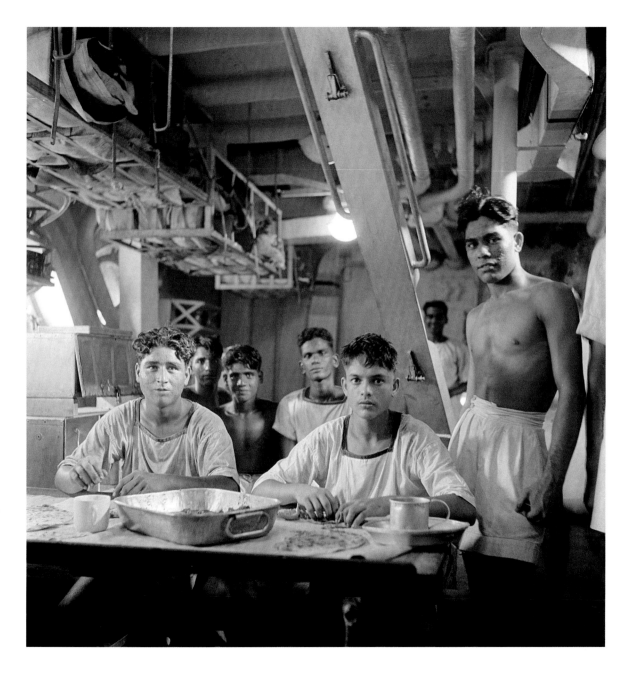

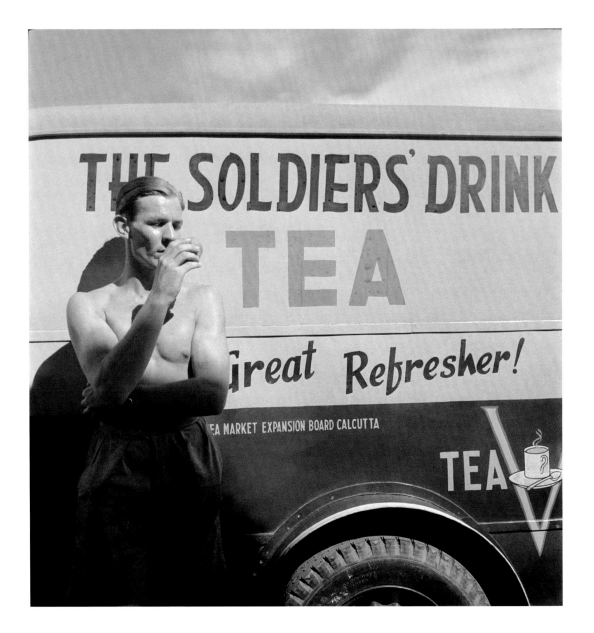

THE SOLDIERS' DRINK
TEA
Great Refresher!

EA MARKET EXPANSION BOARD CALCUTTA

TEA

A soldier having a cup of tea from a mobile tea wagon in Calcutta, India, 1944. This service was provided behind the front lines for wounded troops.

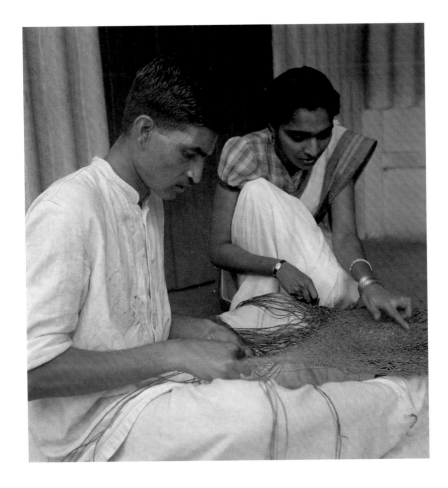

Scene from an Indian Military Hospital in Calcutta, India, 1944. A woman assists in the rehabilitation of a soldier by teaching him to plait string, perhaps for fishing nets.

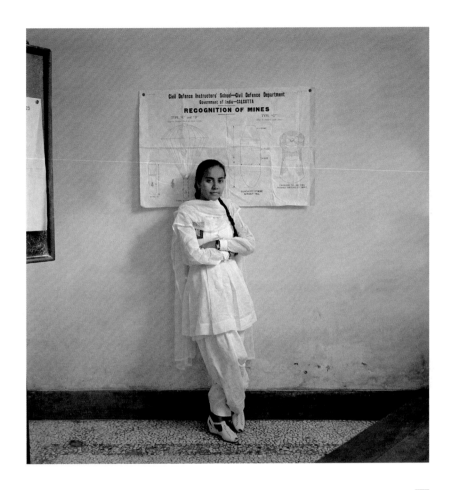

An Air Raid Precautions (ARP) First Aid Post in Calcutta, India, 1944. The woman pictured trained others to identify and handle landmines and incendiary bombs.

General Sir Claude Auchinleck,
Commander-in-Chief, India, 1944.

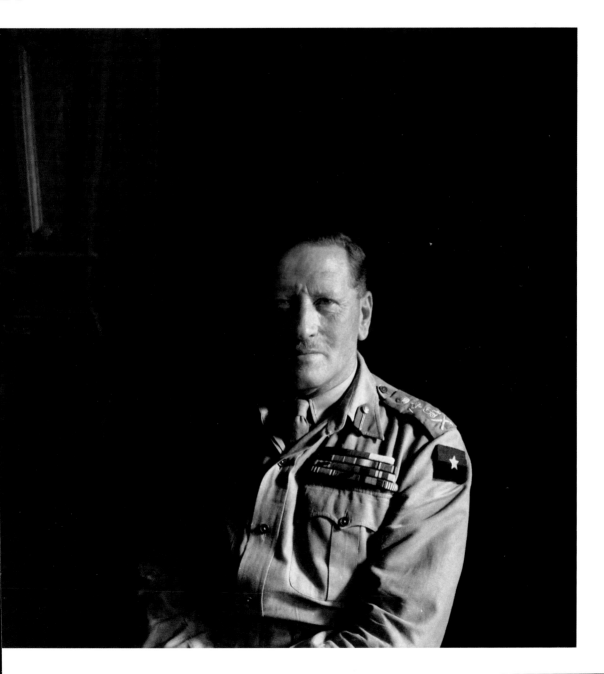

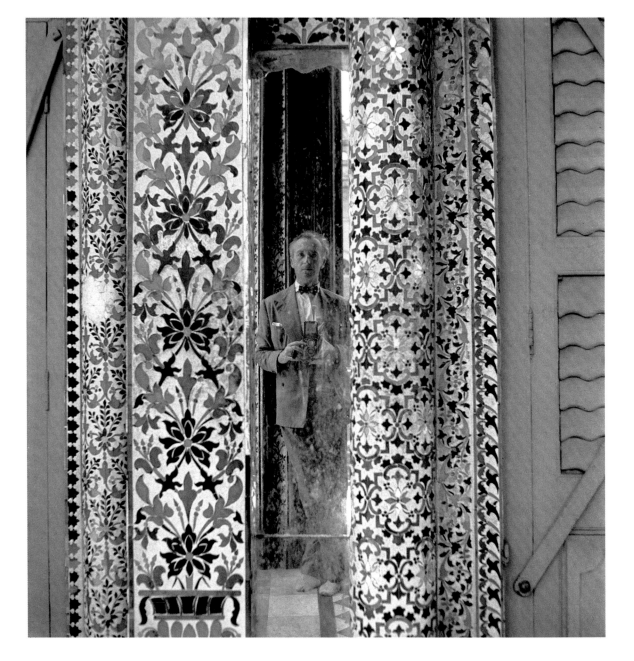

A self-portrait of Beaton, taken in a mirror at the Parshwanath Jain Temple in Calcutta, India, 1944. He described it as 'crystallised fruit, Turkish delight architecture'.

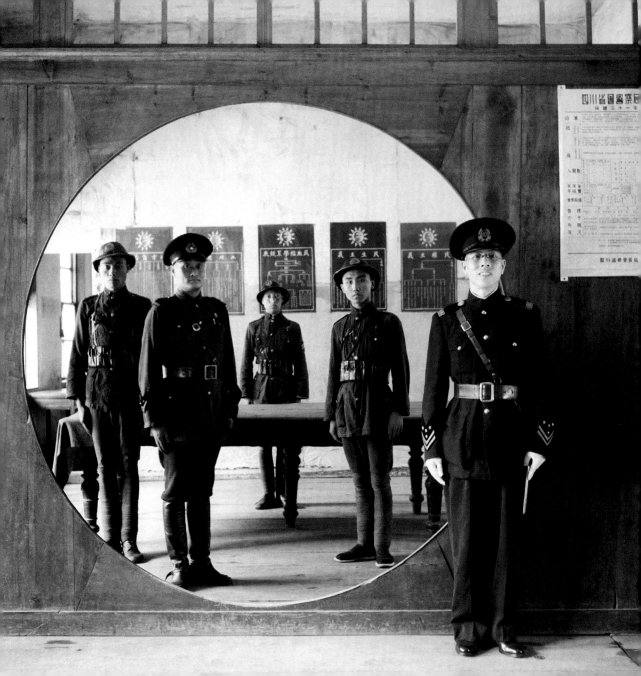

The Assistant Chief of Police
with members of his force at the
police headquarters in Chengdu,
Sichuan, China, 1944.

Two Chinese soldiers in gas masks
at Pihu Military Training Centre
in South Eastern China, 1944.
Here we see how Beaton used his
fashion photography sensibilities
to capture some of the strange
and grotesque aspects of war.

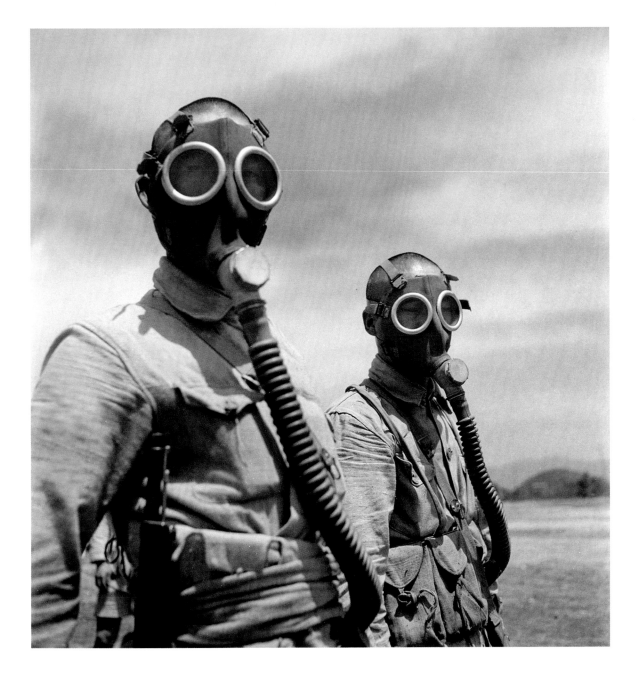

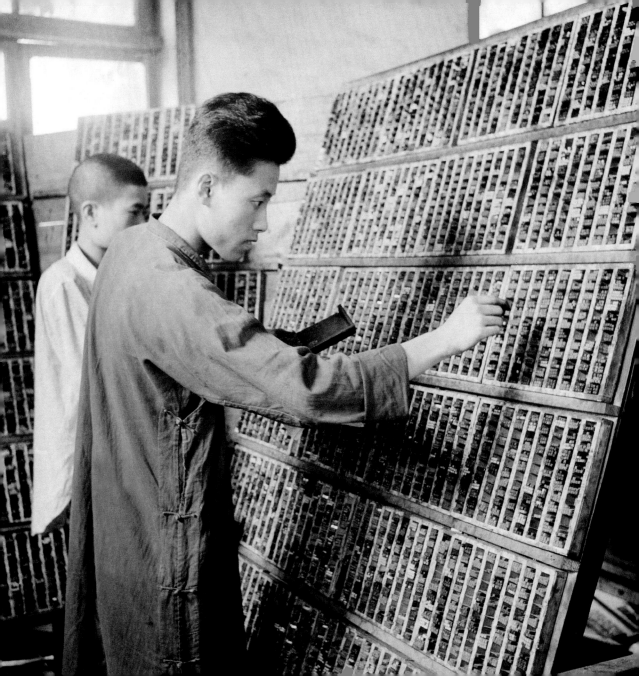

A printer setting type at the
Canadian Mission Press, Chengdu,
1944. Beaton's Chinese visit was a
whirlwind of assignments, and he
photographed many locations and
dignitaries over just a few months.